Canadian Museum
Human Rights

Director's Tour

S
C
A
L
A

CANADIAN MUSEUM FOR
HUMAN RIGHTS

Preface

I am very pleased to have the opportunity, through this short book, to offer you a tour of the Canadian Museum for Human Rights. I want to share my favourite parts of the Museum – its stories, its architecture and its artifacts – just as if we were walking through each gallery together. While we are touring, I will also draw from the collective experience of many different visitors I have accompanied through the Museum, and I'll reference some of the questions and comments they've raised.

This book does not cover all the content found in the Canadian Museum for Human Rights, nor does it seek to replace the experience of actually visiting the Museum. Rather, I hope this Director's Tour will entice you to visit or enhance your experience if you already have – no matter how many times you've come or how long you've stayed. I hope this book will also convey my enthusiasm for the work we do here. I am indebted to those who launched this audacious project, who persevered and brought a dream to reality – as well as to the inspiring people whose stories we tell.

I have occasionally heard potential visitors express reluctance to experience the Museum, believing that they must first "prepare themselves" for the content. While it's true that the Museum's stories include tragic examples of inhumanity, both past and present, what resonates most is the spirit of survivors and the courage of those who took a stand for their own rights and the rights of others. In this regard, I believe the overall Museum experience inspires us to better appreciate the rights we enjoy. It cultivates gratitude for the commitment and sacrifices of others. It strengthens our resolve to treat others with respect. It encourages us to passionately pursue our obligations to pass on to future generations vibrant communities that resonate with our individual and collective responsibilities for human rights.

John F. Young, President and CEO.

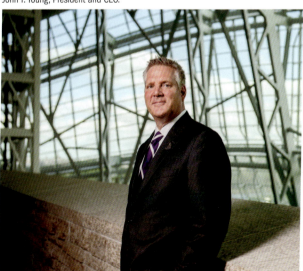

Welcome

L et's start our tour of the Canadian Museum for Human Rights in Bonnie & John Buhler Hall – a large room on the ground level, just beyond the main entrance. On a typical day, you will find an architectural model of the Museum in the middle of this hall. This is where we usually invite visitors to pause while we deliver a few introductory comments.

I welcome you by first acknowledging the ancestral land upon which the Museum rests, which is Treaty One territory and in the heartland of the Métis people. This land at the confluence of the Red and Assiniboine rivers is commonly called The Forks. It has served as a gathering place for Indigenous Peoples for countless generations. Prior to construction, we commissioned the largest block archaeological excavation ever conducted in Manitoba, which recovered more than 400,000 artifacts, some dating

▲ The bronzed moccasin print in Bonnie & John Buhler Hall connects us to Indigenous ancestors who followed the waterways here for peace-making, trade and dialogue.
▶ Welcome wall in Bonnie & John Buhler Hall.

back a thousand years. Fragments of ceremonial pipes and of ceramic pottery reveal much about the importance of this location as a place where people lived, built alliances and gathered for trade and celebration. One of the more remarkable findings was a moccasin print that had been preserved in the earth for about 750 years. We cast this impression in bronze to showcase in Bonnie & John Buhler Hall, honouring those who walked here on these ancestral lands long before the Museum appeared.

In this hall, you will also find a large animated welcome wall, projecting silhouettes of people writing "welcome" in 38 languages. These languages include French and English (Canada's two official languages) and 12 Indigenous languages. Another prominent feature is a striking installation by Indigenous artist David Thomas. To create this piece, Thomas stretched a membrane across a two-and-a-half-metre drum frame. He then placed earth from the site and sacred medicines such as sage, sweetgrass, tobacco and cedar upon the membrane, then "drummed" them into place – where they became the essence of a drum beat in visual form.

I now want to tell you about the origins of the Canadian Museum for Human Rights, which opened its doors in September 2014. The vision was born many years earlier, the adventurous ambition of a courageous and charismatic individual. As a prominent businessman, media magnate, local politician, and devoted Canadian, Israel (Izzy) Asper

Israel Asper, OC, OM, QC, LLD.

first laid out a vision for this Museum in the year 2000. Motivated by his devotion to Canada and his desire to cultivate an appreciation for human rights among future generations, Asper dreamed big: "Either the museum was going to be an architectural icon and change the face of Winnipeg and Canada," he stated, "or it was not worth doing at all." His plans remind me of the sentiment expressed by Daniel Burnham, the 19th-century Chicago architect, here slightly paraphrased:

Make no little plans. They have no magic to stir one's blood and probably themselves will not be realized. Make big plans; aim high in hope and work, remembering that a noble, logical diagram once recorded will never die, but long after we are

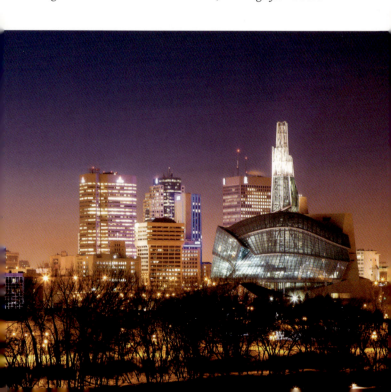

gone will be a living thing, asserting itself with ever-growing
insistency. Remember that our children and grandchildren
are going to do things that would stagger us. Let your
watchword be order and your beacon beauty. Think Big.

Izzy Asper's vision was not warmly embraced by
everyone. Some thought it too audacious for Winnipeg or
Canada. Others thought the price tag too unrealistic and
vocally opposed requests for public investment. The very
notion of an "ideas museum" – rather than a traditional
institution premised on a collection of artifacts – also
raised doubts. Yet Asper's vision was fully in harmony
with Canada's developing identity as a country that
embraces the concepts of inclusion and diversity. In some
ways, the initial resistance to Asper's vision parallels the
development of human rights. At the outset, a specific
rights claim might challenge and disrupt the status quo,

The Museum is in the heart of Winnipeg, where the Red and Assiniboine rivers meet.
Nearby is l'Esplanade Riel (right), a walking bridge connecting the city's historic
French community to downtown.

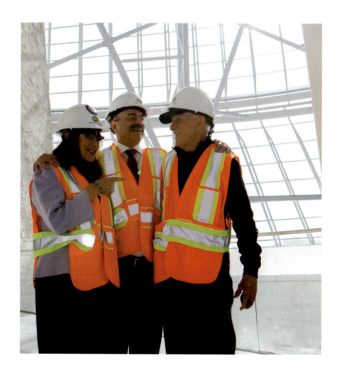

but over time the claim is recognized and then even seems self-evident. Within a few years of opening, the Museum has been widely embraced as a prominent fixture on the Winnipeg skyline, on its way to becoming an iconic symbol of Canadian identity.

Asper passed away in 2003, but the passion needed to build the Museum continued to burn in his family – his wife Babs, daughter Gail, sons David and Leonard, and the Asper Foundation, led by Moe Levy. Due to their combined efforts and subsequent commitments from other generous supporters, the ranks of benefactors continued to grow over the next decade. In the end, more than 8,000 donors contributed over $151 million CAD to build the Museum, the largest capital campaign ever undertaken by a national cultural institution in Canada.

◀ The glass cloud represents the folded wings of a dove, a symbol of peace.
▲ Left to right: Gail Asper, Moe Levy, and Museum architect Antoine Predock.

That success spurred contributions from the Government of Canada, the Province of Manitoba and the City of Winnipeg, creating a unique partnership supporting the $351-million CAD capital project.

The Canadian Museum for Human Rights was officially established as a national museum in 2008 through amendments to Canada's Museums Act. Although the Museum would not open for another six years, the Act clearly articulated its mandate to enhance public understanding of human rights, promote respect for others, and cultivate dialogue and reflection on human rights themes. This is a unique mandate, quite distinct from more traditional responsibilities of other national museums to collect and preserve the material heritage of science, nature or history. Instead of objects, we collect stories. Instead of a collection of monuments and artifacts, it focusses on the experiences and conversations of Canadians, seeking to capture and expand our collective memory related to human rights.

Now, let's talk about the architecture. The five-year construction project started in 2009. The architect, Antoine Predock of New Mexico, had been selected five years earlier through a juried international architectural competition. Predock's winning design proposed an aspirational human rights journey connected to the Canadian landscape. The design has four major components: first, four stone "roots" that connect the building to the land and with our past, drawing strength from both; second, a "mountain" of limestone that houses the Museum's core galleries, jagged and rough and representing an arduous climb; third, a glass "cloud" comprised of 1,669 uniquely shaped panes that embrace the Museum as the folded wings of a dove; and fourth, the glowing beacon that projects from the top of the Museum like an unfinished tower. This unfinished appearance is a

◀ The interior of the glass cloud houses office space, the Stuart Clark Garden of Contemplation and elevators to the Israel Asper Tower of Hope.

▶ The Israel Asper Tower of Hope is a 23-storey glass spire, rising 100 metres into the sky.

reminder of the work that lies ahead as humanity strives to respect the dignity and rights of all.

Predock has also created a journey that winds its way up 800 metres of magnificent, glowing alabaster ramps, climbing more than 100 metres in elevation through 11

The ramps clad in pale Spanish alabaster are lit from within, creating a glowing pathway of light through the darkness, represented in some areas by black concrete walls.

galleries and five theatres. The journey culminates high inside the Israel Asper Tower of Hope, which provides panoramic views of Winnipeg and the prairie beyond.

The iconic architecture interacts with different exhibits throughout the visitor experience, as most galleries can be viewed from a variety of angles and perspectives – sometimes retrospectively, sometimes prospectively. The building is a magnificent home for the Museum and a marvelous forum for sharing the many stories we tell.

Before we begin to explore, I'd like to explain that the journey ahead will take us through different exhibitions and galleries, all designed to engage visitors with inspiring stories that underscore the importance of human rights. While artifacts provide multiple opportunities to connect with human rights experiences, it is through various technology and media that we invite you to engage more directly with the content. You will find passive, active and interactive technologies and – sometimes – augmented and virtual reality.

So, let's get going!

What Are Human Rights?

In the first gallery, we are immediately confronted with a fundamental question: "What are human rights?" The question is not intended to solicit a single, authoritative answer. Instead, it invites you into a dialogue. The physicist David Bohm has suggested that the object of meaningful dialogue is not to analyze things or win an argument. Instead, he says that dialogue requires suspension of opinion and active engagement in listening, as a way to

understand the perspectives of others. Such engagement cultivates shared meaning – an important glue that can hold people and societies together.

To this end, the beginning of this first gallery gives you an opportunity to hear different Canadian voices sharing their perspectives on human rights. We first see four life-sized "video people" sharing their views. On the opposite wall, a multimedia presentation further explores the concept and origins of human rights, highlighting the importance of human rights education and how rights connect us to each other. The film also notes the task of balancing different values such as equality, respect, agency and liberty. It invites all of us to identify common values that can overshadow our specific differences. In discussing freedom

of expression, for example, we hear one voice advocating that you should not "feel scared to express yourself and share what is on your mind."

Whenever I am in this first gallery, I'm reminded of a personal experience. To understand its impact on me, I need to first explain that, before working for the Museum, I spent more than two decades teaching university students. As a professor, I often found it worthwhile to draw from Michael Ignatieff's work *The Rights Revolution*, in which he proposes that agency – which is both the desire and the capacity to make choices – is a fundamental part of the human condition. As individuals exercise agency, he says, it is a natural consequence that differences become manifest. In other words, differences are the necessary outcomes of choice. As Ignatieff puts it: "To believe in rights is to believe in defending difference." As I told my students, this means that any meaningful commitment to human rights requires respect for those whose opinions and choices differ from our own.

But then I met someone who said it better.

Shortly after starting my work at the Canadian Museum for Human Rights I had a wonderful opportunity to meet with a group of Grade 3 students who'd been on a class visit to the Museum. Afterwards, they prepared a presentation for their school assembly to share what they had learned and they invited me to attend. I will always remember a young lad named Spencer, hair uncombed and tousled. When asked what human rights meant to him, his response was immediate and enthusiastic – perfectly summarizing Ignatieff without attribution:

"Human rights," blurted out eight-year-old Spencer, "means that everyone has the right to be different!" Well stated.

There is power in simplicity. In this first gallery, you will see another powerful human rights statement written in towering white letters on a jet-black wall – the first article

Timeline in the What are Human Rights? gallery.

of the Universal Declaration of Human Rights, adopted
by the United Nations in 1948. It simply says: "All human
beings are born free and equal in dignity and rights." This
is one of the most frequently shared images on social media
by Museum visitors.

Continuing through this first gallery, we stroll along a
timeline that includes 100 people and events that have
influenced human rights history around the world. It
includes such names as Confucius, Jesus of Nazareth,
Harriet Tubman and Louise Arbour. Its intent is to cultivate
dialogue that encourages visitors to further explore the
meaning of human rights and help them connect the
concept of human rights to their own diverse traditions.
That's why the timeline makes no claim to be a definitive
ranking of the most important persons and events in
human rights history, but instead invites you to think
about other people and events that could be included.
In my own version of the timeline, for example, I would
happily include William Wilberforce, the British Member
of Parliament and abolitionist who laboured so diligently

against slavery for 45 years. I might also suggest my personal hero Václav Havel, the dissident Czech playwright who made the journey from political prisoner to president of his country.

Who would you choose? Considering such a question encourages thoughtful conversation, occasional disagreement and adds perspective to the concept of human rights.

Here in this first gallery, we are also introduced to the Museum's special insight stations, where you can explore its content in greater depth. We will see these stations throughout the Museum. They reflect its commitment to accessibility for people of all abilities. A universal keypad offers tactile navigation buttons that allow blind and low-vision visitors to use the touchscreens, after plugging their earbuds into the ports. A "cane stop" on the floor at each station alerts blind visitors that there is something interesting to explore. There is also a wrist rest for those with limited arm mobility. The stations are also built to a height that accommodates wheelchairs.

The Museum is one of the most accessible cultural institutions in the world, surpassing Smithsonian standards for inclusive design.

Throughout the building and in all its exhibits, accessibility is carefully considered in every context. We work with an Inclusive Design Advisory Council, comprised of people with diverse abilities from across the country. We consider things like the size and typeface of text, the colour palettes, and wayfinding using Braille and raised characters. All videos include American Sign Language and Langue des signes Québécoise, descriptive audio and captioning.

An award-winning mobile app provides a fully accessible self-guided tour using audio, images, text and video. Throughout the museum, over 150 "iBeacons" flow additional information into your mobile device through the app – allowing blind visitors to understand (through

their text-to-speech readers) what is written on walls or embedded in images.

A few months after we opened, we were honoured to receive a prestigious Jodi Award at a ceremony in London, England, where judges called Canada's new national museum "a beacon of excellence in digital inclusivity, not only in Canada but worldwide." The Jodi Awards recognize innovation and excellence in the use of digital media to widen access to museums, galleries, heritage sites, libraries and archives. Past winners include the Tate Modern and the British Museum.

As we continue walking, we pass by three bench cases in the middle of the gallery. These glass cases house temporary exhibits on selected themes. Here, the Museum has explored such topics as sport and human rights, freedom of expression, and labour rights. Artifacts displayed here have included a running dress or "tutu" worn by Kathrine Switzer, the first woman in the Boston Marathon, and the Olympic gold medal won by Canadian swimmer Mark Tewksbury, a long-time defender of the rights of people of diverse sexual orientations and gender identities.

Indigenous Perspectives

Moving past the first gallery, we now enter Indigenous Perspectives, where we find a tall, circular theatre that resembles a woven basket. Inside is a 360-degree film that shares Indigenous Peoples' stories and understandings of our responsibilities to each other and to the land. We watch a powerful, seven-minute presentation that highlights a worldview in which everyone and everything is interrelated. I admire the way this film uses four different perspectives from four generations of Indigenous women to communicate the obligations we owe not only to one another, but also to those who have come before us and to those who will follow.

On the exterior of the basket theatre are 13 works of art called spirit panels. They convey artistic interpretations of Indigenous rights and were created by Indigenous youth, elders and artists working together at workshops held in communities in each of the 13 provinces and territories of Canada. Each panel can be explored in greater detail in the nearby insight station, and also through the Museum's website.

On the other side of the basket theatre we find *Trace*, a powerful work of art by Anishinaabe artist Rebecca Belmore. Using Red River clay, Belmore invited hundreds

of participants to squeeze thousands of hand-formed clay beads to leave the impressions of their fingers. The beads, which were then fired and strung together, created a work resembling a giant hanging blanket, a symbol of respect, recognition, and comfort. *Trace* reminds us of both our imprint on the earth and our interconnectedness. No individual bead could evoke such an image or meaning but, when placed together, they make a powerful statement.

On the west wall of Indigenous Perspectives we examine three installations where Indigenous writers share their insights about the sacred balance between people and nature, concerns about the environment, and the

▾ One of the 13 spirit panels created for the Museum.

displacement of Métis communities. Taiaiake Alfred highlights how Indigenous traditional knowledge can inform our contemporary understanding of human dignity. Maria Campbell explores the harm to Indigenous Peoples by colonization. Joséphine Bacon invites us to reflect on the tensions between resource extraction and the peoples who live on the land. We also see a seven-metre-high Métis beaded fire bag (also known as an "octopus bag") by Jennine Krauchi, believed to be the largest in the world.

The Indigenous Perspectives gallery has the only outdoor terrace in all of the Museum galleries. This addition to the building plan was made based on feedback from Indigenous Elders, who recommended we provide ceremonial space and enable visitors to connect the concepts of Indigenous rights to the land on which the Museum rests.

As we leave these first two galleries, you get your first glimpse of the alabaster ramps on the journey ahead. The many zigs and zags of these ramps and the stunning effect of the illuminated alabaster is a common image shared by our visitors.

◄◄ Artist Rebecca Belmore used more than 10,000 hand-formed clay beads to form *Trace*. It spans from the second to fourth level of the Museum.
▾ This Métis fire bag with traditional floral beadwork by Winnipeg-based artist Jennine Krauchi features the names of nine displaced Métis communities.

Canadian Journeys

The next gallery is the Museum's largest and most visually impressive exhibit space, a place that explores Canada's own steps and missteps on the path to greater human rights for all. Eighty stories are presented in various ways: through 18 exhibit alcoves on three sides of the gallery, through a 30-metre digital canvas and through image grids found higher on the walls, which connect to stories in digital insight stations on the floor. A theatre shows two films produced by the Museum: an overview of the evolution of human rights in Canada and an account of Indian Residential Schools and their damaging generational legacy.

The 18 alcoves contain exhibits dedicated to important human rights themes and events in Canada. These include the internment of Japanese Canadians during the Second World War, women's rights, the refugee experience in Canada, missing and murdered Indigenous women and girls, labour rights and the Winnipeg General Strike, voting rights, marriage rights, language rights, Indian Residential Schools, Chinese head tax and restricted immigration, disability rights, the rights of Peoples of the North, religious liberty, the Underground Railway and slavery, Métis rights, the War Measures Act, Viola Desmond and racial segregation in Canada, and migrant workers. Another alcove gives you the opportunity to share your own human rights story.

We then step into the middle of the gallery, onto an interactive experience called "Lights of Inclusion." We are each suddenly surrounded by a bubble of coloured light that follows us as we move within the circle on the floor. When we move close to each other, the coloured lights interact and change colour, with ribbons of energy now

▲ A 30-meter-wide digital canvas in Canadian Journeys showcases faces of Canadian human rights champions and six silent films on human rights in Canada.

▼ Each alcove features a human rights theme or event in Canada.

▼ The Banned From the Ballot exhibit alcove shares stories about the right to vote.

flowing between them. As more people join the circle, they become even more interesting. This game teaches children of all ages that good things come from including others into our sphere of influence, regardless of difference. It is one of the many different ways the Canadian Museum for Human Rights uses technology to engage our visitors.

Another example of interactive technology is found in the exhibit alcove about the refugee experience in Canada. Here, we turn a tactile globe to select a country of origin, then watch short videos of personal stories from people who have found a new home in Canada. This alcove is one of our most popular interactive exhibitions. One of my personal favorites is the account given by Kim Bui, who came to Canada as a refugee from Vietnam in the early 1980s. Among the hundreds of thousands of refugees, Kim's story is a powerful reminder of the safe haven offered to refugees and the reciprocal benefits to both newcomers and country.

Next to this alcove, the exhibit on missing and murdered Indigenous women and girls consists of an art installation by Indigenous artist Jaime Black called *The REDress Project*. Featuring empty red dresses hanging against a woodland background, this artwork demonstrates that

The Lights of Inclusion experience in the Canadian Journeys gallery.

sophisticated technology is not the only way for exhibits to be powerful and effective. *The REDress Project* is likely the most photographed exhibit in the Canadian Journeys gallery.

Another exhibit alcove, Taking the Cake, takes a celebratory tone. Here, we see a huge wedding cake made from tiered wedding photographs – crowd-sourced from same-sex couples across the country. In 2005, Canada became the fourth country in the world to legalize same-sex marriage. This exhibit points to the hard work of the community in speaking out for rights and inclusion.

Looking up above us, we watch as the 30-metre-wide digital canvas plays six short, silent films about Canadian human rights themes and events: the expulsion of the Acadians, the rejection of South Asian immigrants aboard the ship Komagata Maru, challenges faced by conscientious objectors, wartime internment, freedom of assembly, and Indigenous land rights. We then turn our attention to the

array of faces on the image grid which surrounds us on the upper walls of the gallery. They invite us to explore dozens more Canadian stories in the floor-level insight stations on themes including Indigenous peoples, veterans, people of

⌄ *The REDress Project* in the Canadian Journeys gallery.
⌄ The Who Gets In exhibit alcove features refugee experiences at Canada's gates.

diverse sexual orientation and gender identity, health care, religious freedom, disability rights, prisoners' rights and wrongful convictions. One example is the story of Leilani Muir, the Alberta woman whose forcible sterilization as a teenager was decided by the Alberta Eugenics Board under the provincial Sexual Sterilization Act after she had been incorrectly identified as mentally deficient. Told she was having her appendix removed, she did not know about the sterilization procedure until later in life. This was not a unique story: more than 2,800 people were forcibly sterilized in Alberta between 1928 and 1972. A less severe eugenics law was also found in British Columbia. Muir successfully sued the provincial government in 1995 and her efforts helped reveal the gross violation of rights associated with the eugenics movement.

All Canadians should know the stories told in this gallery. Unfortunately, this is not yet the case. In 2015, I had the opportunity to tour one of Canada's most prominent public historians through the Museum. As we examined the alcove that contains the account of Viola Desmond and racial segregation in Canada, the historian turned to me and candidly admitted "I did not know this story." The importance of the work of the Canadian Museum for Human Rights in expanding the public memory of Canadians became very clear to me.

Shortly before escorting this public historian through the Museum, I had spent time with a class of young students visiting the gallery. They were also interested in the exhibit about Viola Desmond. Let's walk over there now, to an alcove built to resemble a 1940s movie theatre complete with red leather seats and red velvet curtains.

Desmond is the Black Nova Scotian who took a stand against racial segregation in Canada – she is now featured on Canada's new $10 banknote (and our Museum appears on the other side!). In 1946, Desmond caused

◀ Taking the Cake exhibit alcove features a crowd-sourced photo collage replicating a tiered wedding cake.

One Woman's Resistance shares the story of Viola Desmond. This exhibit resembles a movie theatre with seats in which visitors can sit.

a commotion when she decided to sit in the section of a local theatre in New Glasgow reserved for white people. Although she attempted to purchase a general admission ticket, she was denied by the ticketing clerk. When she went and sat in the general audience seating regardless, Desmond was arrested, spent the night in jail, and was eventually found guilty in court – of a bizarre interpretation of tax evasion. Her appeals to have the conviction overturned were unsuccessful. Many Canadians are surprised to learn that this story of racial segregation is part of the Canadian experience.

When the students approached the Museum's exhibit about Desmond, one was eager to demonstrate her knowledge: "Is this Rosa Parks?" she asked, referring to the Alabama woman who protested against segregation by sitting in the white section of a public bus, sparking the Montgomery Bus Boycott of 1955.

It amazed me that Canadian students were so familiar with stories of racial segregation in the United States but did not know nearly as much about the Canadian experience.

I pointed out that Desmond's protest happened nine years before Rosa Parks took her seat on that bus in Alabama, and I watched with interest as they learned more.

It is clear that our public memory is fluid and dynamic, complex rather than singular. Public memory is the sum of disparate shared experiences. The sharing that creates that sum is part of our ongoing common responsibility, across both time and space.

That is why Canadians need to know these stories. Whether they are about racial segregation, a ban on Chinese immigration, missing or murdered Indigenous women and girls, or the persecution of religious groups, these experiences become part of our collective experience and identity as Canadians. The Canadian Museum for Human Rights seeks to play a meaningful role in sharing these lived experiences and understanding them in order to expand our public memory and cultivate our national identity.

The example of Viola Desmond is only one of the important stories told in the Museum that should be fundamental to our collective experience as a country. Some of these stories are drawn from events that occurred within the borders of Canada; others happened elsewhere (such as the Armenian Genocide, the Holodomor, the Holocaust and many others), but are still part of the lived experience of Canadians and their descendants. These profound experiences deserve to become part of Canada's public memory. And the Museum plays a role in sharing these and connecting them to our national identity.

Continuing on our tour, we are drawn to the alcove that contains testimonies from survivors of Indian Residential Schools, Childhood Denied. I have been asked by a number of Canadian visitors why they were never taught about this in their own schools during decades past. Other visitors sometimes wonder whether or not such testimony of the past should matter. Isn't it more important, they ask, to focus on the future?

Senator Murray Sinclair, who chaired Canada's Truth and Reconciliation Commission, has highlighted that museums exist to create, mold and shape our national memory. We believe this is critical work, and it is through engaging in and facilitating dialogue, and the sharing of experience and perspective, that this will happen.

Senator Sinclair has also noted that on numerous occasions, he too has been asked: "Why don't residential school survivors just get over it?" I think his response is worth repeating frequently:

The Childhood Denied exhibit alcove shares stories about Indian Residential Schools and their legacy.

My answer has always been, why can't you always remember this? Because this is about memorializing those people who have been the victims of a great wrong. It is because it is important to remember. We learn from it. And until people show that they have learned from this we will never forget. And we should never forget even once they have learned from it, because this is a part of who we are. It's not just a part of who we are as survivors and children of survivors and relatives of survivors, but part of who we are as a nation. And this nation must never forget.

Protecting Rights in Canada

We now step onto the glowing alabaster ramps for the first time, on our way to the next gallery. I hope you will recognize the important symbolism expressed by the ramps. Firstly, they do not proceed along a simple straight line, but zig and zag forward and back – not unlike the pursuit of human rights, which often involves taking two steps forward then one step back. Secondly, the choice of alabaster was more than aesthetic. Alabaster is not only beautiful, it has a symbolic past, being frequently used as a container for salves and ointments to heal pain.

We soon arrive at the next gallery, Protecting Rights in Canada. Canada's legal system combines three traditions, both written and unwritten. These include Indigenous legal traditions, French civil law and English common law.

Former Chief Justice of the Supreme Court of Canada, Beverley McLachlin (left), visits the Protecting Rights in Canada gallery and views the Legal Traditions case.

As we note in this gallery, together these traditions form a strong, flexible legal framework that provides support for human rights in Canada. We have not always gotten things right, but the steady advance of human rights is reflected in and encouraged by our legal system. As noted by Beverley McLachlin, the former Chief Justice of the Supreme Court of Canada: "Like every other human institutional endeavor, justice is an ongoing process. It is never done, never fully achieved. Each decade, each year, each month, indeed each day, brings new challenges."

In this gallery we examine how some of these challenges have been addressed by the courts. You see historic artifacts and documents, some of which we have borrowed from partner institutions. Examples include the Proclamation of the Constitution Act of 1982, treaty documents, and articles from the Supreme Court. We also come upon a simple stenographer's pad – a notebook carried by women activists in 1981 to disguise themselves as secretaries and gain entry into Parliament. Once admitted, they could then lobby for a gender equality clause in the development of the Charter of Rights and Freedoms. The notepad on display, from Senator Marilou McPhedran, who was part of that group, reminds us how our conversations and deliberations regarding rights have not always been inclusive.

Turning around, we can now explore an interactive debate table. In this participatory exhibit, many landmark court cases in Canada connected to the Charter of Rights and Freedoms are reviewed. These cases include decisions regarding employment equity, treaty rights, sexual orientation, the right to die, freedom of speech, religious freedom, the right to health care, and others.

The Keegstra case, for example, was decided by Canada's Supreme Court in 1990. This landmark decision on freedom of expression in Canada upheld the constitutionality of the hate speech provision in the Criminal Code of Canada. The accused, an Alberta high school teacher and small-town mayor named James Keegstra, had been charged in 1984 with willfully

promoting hatred by making anti-Semitic statements to his students. Keegstra described Jewish people as treacherous, subversive, and child killers; he told his classes that the Jewish people were responsible for economic depressions, war and revolution. He also claimed that Jewish people "created the Holocaust to gain sympathy" and expected his students to reproduce his teachings in class assignments and exams. Keegstra's conviction had been overturned by the provincial Court of Appeal of Alberta and came to Canada's Supreme Court on appeal. Keegstra's defence argued that the section of the Criminal Code regarding hate speech violated Article 2 of the Canadian Charter of Rights

and Freedoms, which guarantees freedom of thought, belief, opinion and expression, including freedom of the press and other media of communication.

As with all the cases reviewed here, the debate table draws from video clips of television news broadcasts to provide context and insight to the central legal questions of the court challenge. We press the "participate" buttons to weigh-in and register our opinions on the various

At the debate table, visitors are encouraged to explore multiple sides of landmark court cases and then choose how they would vote on tablets in front of them.

For the Stuart Clark Garden of Contemplation, stonemasons hand-chiselled the basalt stone sourced from Mongolia.

cases. Results are calculated around the table and shared anonymously on screen. The results from our sessions are then compared with the sum of all results by everyone who has ever participated. At the end, our "verdict" is compared with the decision of the Supreme Court.

Departing the Protecting Rights in Canada gallery, visitors can either proceed further along the ramps to the next gallery or enter the Stuart Clark Garden of Contemplation. This garden provides a serene setting for reflection and conversation. It is notable for its ponds and hundreds of basalt stones – a volcanic rock type that can be found in every region of the world and is, therefore, "everyone's rock." This is also an appropriate place to pause during a descent from the Israel Asper Tower of Hope at the end of a visit to the Museum.

Fourth floor

Laws themselves are no guarantee of human rights. As we will see in the next set of galleries, all members of society play a role in promoting human rights. Here, on the fourth floor, we start examining human rights themes from a global perspective. The first gallery on this floor, called Examining the Holocaust, draws attention to the ways the Nazi government of Germany used law and violence to deprive people of their rights as citizens and as humans. When the majority of the population went along with prejudice and persecution of minorities, when they tolerated violations of human rights and abuse of state power, the genocidal murder of six million Jewish people was the horrific result. This gallery also examines persecution of the Roma, people of diverse sexual orientation, Jehovah's Witnesses, and persons with disabilities. Our approach seeks a balance between the specific experience of the Holocaust and the universality of human rights by focusing on themes common to both. The pursuit of this balance is not to undermine the uniqueness

The "broken glass" theatre in the Examining the Holocaust gallery.

of the Holocaust but to develop a broader human rights perspective on this atrocity. This perspective is then augmented through a study of the concept of genocide and human rights violations elsewhere.

In the middle of the gallery, we take a seat in the "broken glass" theatre where a documentary account of anti-Semitism in Canada reveals that this experience was not limited to Europe. The film includes, for example, the story of the SS St. Louis. Many Canadians today don't know that Canada had one of the worst records among refugee-receiving countries before and during the Second World War. Among those rejected were the passengers of the St. Louis. Seeking refuge from Nazi Germany, more than 900 Jewish emigrants began their voyage on this ocean liner in May 1939, four months before the beginning of the Second World War. Their original destination was Cuba, but the Cuban government changed its immigration policy during the same month that the ship left the port of Hamburg in Germany. Upon arrival in Havana, only a few dozen passengers with specific visas were allowed to disembark, and the ship's captain appealed to other countries on behalf of what were now refugees.

The government of the United States prevented the St. Louis from docking alongside any of the states on its eastern coast. Appeals to Canada were also rejected, despite efforts of clergy and academics to persuade the Canadian government to admit the refugees. The government under Prime Minister William Lyon Mackenzie King was staunchly against Jewish immigration, a policy characterized by an infamous answer given by an unidentified immigration agent. When asked how many Jewish people would be allowed in Canada after the war, the agent answered, "None is too many." That phrase, and the story of the St. Louis, have become stark examples of Canada's shameful stumbles in the past.

Along the three walls of the Holocaust gallery we find an array of text, artifacts and stories about the Nazi techniques of genocide: abuse of state power, persecution of minorities, and the relationship between war and genocide. Touching one of the video screens mounted on the walls we watch several tragic video stories about the ways that political regimes have trampled basic human rights. The lived experience under strong authoritarian or totalitarian regimes is often quite difficult to understand for those who know only constitutional democratic governments. In regimes willing to abuse and destroy human rights for ideological purposes, everyday life can be horrific.

One of the video stories tells us about Johann "Rukeli" Trollmann – who was a popular boxer in Germany, of Sinti Romani heritage. Trollmann had his own well-known and unique dancing style of boxing. After Jewish people were officially banned from the sport in Germany (which forced national champion Erich Seelig to vacate the title and leave the country), Trollmann competed for the national light heavyweight title in 1933. When he won the title match, Nazi officials ordered a rematch, threatening Trollman that he would lose his fighting license if he did not adopt a more traditional "Germanic" boxing style and trade blows standing toe to toe. Trollmann arrived at the scheduled rematch with bleached blond hair and powdered white skin to mimic

the appearance of an Aryan fighter. He went toe to toe, receiving his opponent's blows without retaliation for five rounds before he collapsed. While his boxing career never recovered, his defiance of the regime increased his popularity among the Roma community.

The persecution of the Sinti and Roma people escalated under the Nazi regime. Trollmann and others who were deemed racially undesirable faced sterilization and incarceration in labour camps. Despite such abuse, Trollman was drafted into the Wehrmacht in 1939. Then, in 1942, he was arrested by the Gestapo as an undesirable

and interred in a concentration camp. Under these dehumanizing conditions, he was occasionally forced to box against German officers and guards and was eventually murdered by a defeated opponent. It was not until 2003 that the German government posthumously recognized Trollmann as the light heavyweight champion of 1933. This story is more than an account of human rights violations and individual tragedy. It reveals the efforts of a political regime to penetrate all aspects of society, including sports. Our visitors are often dumbfounded when they realize how deeply politics can penetrate all aspects of people's everyday lives.

Continuing to explore the stories of this gallery, we find the remarkable account of Bishop Clemens August von Galen. Born into German aristocracy, he became the Catholic Bishop of Munster in 1933 after three decades as a priest. Although von Galen was the first German Bishop to publicly acknowledge the new regime of Adolf Hitler, he soon became openly critical of Nazi policies, including education, forced sterilization, and eugenics. He also criticized the Nazi expectation of unquestioning loyalty to the regime. He did not, however, protest the Nuremburg laws or public manifestations of anti-Semitism, and his sermons sometimes added to the flames of anti-Jewish sentiments.

Yet Bishop von Galen demonstrated great courage when he publicly criticized the Nazi euthanasia program directed against so-called "unproductive" people: the mentally handicapped and mentally ill, people with physical disabilities, and people with Down's syndrome. The euthanasia program killed many tens of thousands of people between 1939 and 1941 when Bishop von Galen's public campaign against the regime's violations of the most basic of human rights for vulnerable people created a public outcry. Bishop von Galen argued that such a policy undermined the moral fabric of society and the legitimacy of the state. Because of his public profile, the Nazi regime chose not to retaliate against him directly. Instead, three parish priests in his diocese were beheaded.

Parishioners warned Bishop von Galen to refrain from public criticism of the regime, expecting that his life could also be forfeit. His reply captures the courage of those who publicly advocate for human rights: "I am aware of this fact, that this can happen also to me, today or some other day, and because then I shall not be able to speak in public any longer, I will speak publicly today."

I want to draw your attention to some of the artifacts in the Examining the Holocaust gallery. One is a copy of the 1938 children's book, *Der Giftpilz*, which is a painful example of how propaganda was used in Nazi Germany to weaponize

cultural identity and widen cleavages within society. Written as an educational tool for children, the illustrated book uses the metaphor of a poisonous mushroom to warn of the dangers of toxic elements in society. Just as it is difficult to differentiate between edible and poisonous mushrooms, the book asserts, so too is it difficult to make the distinction between gentiles and Jews. The alarmist propaganda is part of the Big Lie and warns of supposed dangers posed by Jewish people to the personal well-being

Interactive stations examine the concept of genocide developed by Raphael Lemkin.

of German children and to society as a whole. The warnings include common and dehumanizing anti-Semitic claims of political, economic and religious peril.

The book shows the depths to which the regime would sink to delegitimize the Jewish people. Its publisher, Julius Streicher, was also the publisher of the most virulent anti-Semitic newspaper, *Der Stürmer*, and a key player in the Nazi propaganda machine. He was later tried at Nuremberg, found guilty of crimes against humanity, and executed.

We now turn our attention to the bust of a Jewish head, which invites speculation about how it was used. Visitors who try to guess rarely understand its purpose. The bust was used as way for visually impaired Germans to use their fingers to study the alleged facial features of Jewish people. The idea was that they could then take steps to protect themselves in social interactions and business transactions.

In the four insight stations on the far side of the broken glass theatre, we learn about the work of Raphael Lemkin, the legal scholar who was the first to coin the term "genocide" in 1943. This important exhibit tells us that Lemkin studied five different atrocities – the Holocaust, the Armenian Genocide, the Holodomor, the Spanish colonization of the Americas, and the British colonization of Tasmania. Examining the similarities and differences among these atrocities led Lemkin to identify and draw attention to the physical, biological and cultural methods that were used to kill whole nations. The Holocaust, for example, used all these methods, which led Lemkin to describe the Holocaust as the most deliberate and thorough genocide in history. It is certainly the most studied – a reflection of its massive scale and also the consequence of the records left behind by a defeated regime.

You may be surprised to discover that genocide is a 20th-century word. Many visitors are bewildered and shaken by the inhumanity that has been manifest in our history. Yet these stories must inform our present. One of the program interpreters at the Canadian Museum for Human Rights

shared an experience that occurred during a group tour of the galleries. In the middle of the Examining the Holocaust gallery, one visitor stepped forward and started using one of the touchscreen monitors. Another visitor in the same group pointed to the screen and said, "Judy, that's you!" Judy Cohen, the woman operating the touchscreen, was featured in the video. The tour paused for all to watch the video, then listened as Cohen shared her experience as a survivor of the Holocaust. As a teenager, she had been deported from Hungary with her family and was sent to the Auschwitz concentration camp. Her entire family perished. Silent tears and emotional reactions naturally followed, drawing attention to the awful realities of crimes against humanity. This anecdote once again shows the power of storytelling to support our living public memory.

Holocaust survivor and Nobel laureate Elie Wiesel has suggested that "There may be times when we are powerless to prevent injustice, but there must never be a time when we fail to protest." As we depart the Holocaust gallery, we

The Breaking the Silence theatre.

reflect upon this call to speak out. Words are powerful: when people dare to break the silence about mass atrocities they promote the human rights of all.

Leaving Examining the Holocaust, we go next to a small theatre in a gallery around the corner called Breaking the Silence. Here, we watch documentary films produced by the Museum that explore our collective awareness of genocides, such as the mass slaughter of Armenians in the Ottoman Empire and the deliberate starvation of millions in Ukraine perpetrated by Stalin and the Soviet government. The extent of both atrocities has been disputed by the perpetrators, so the theme of Breaking the Silence is common to these and other experiences.

In the first film, the Armenian Genocide is seen through the lens of First World War German Army medic and pacifist Armin T. Wegner, who tried to alert the world about this mass atrocity through his writing and photography. He witnessed the expulsion and death marches of Armenians by the Turkish Army. Despite orders to the contrary, Wegner took hundreds of photographs of the deportation camps and atrocities that were part of the genocide. He also gathered information and documents. This evidence informed his book, *Der Weg Ohne Heimkehr* (*The Road of No Return*), written shortly after his return to Germany. Wegner became an early and prominent activist devoted to drawing attention to the plight of the Armenians.

The genocide of some 1.5 million Armenians is still disputed today by the government of Turkey, even as it is recognized by 29 different countries and universally by genocide scholars and historians. The Museum's documentary explores the history of the genocide and highlights Wegner's efforts to generate greater public awareness of these crimes. It also tells us that Wegner was later motivated to publicly denounce the Nazi persecution of Jewish people and was arrested and incarcerated in a labour camp in 1933. He ended up fleeing to Italy, where he lived for the rest of his life. By framing the Armenian Genocide with the experience of Armin Wegner, we invite

visitors to ask themselves how they would respond to such tragedy. Wegner's commitment to the dignity of all people and his courage to speak out in the face of opposition should be recognized as exemplary.

We now watch the second documentary, which is an account of the Ukrainian famine, or Holodomor. I am still surprised that many of visitors know little or nothing of these two genocides. My own understanding of the Holodomor began through my Ukrainian heritage. I recall hearing about the famine of 1932 to 1933 through references by my maternal grandparents to the consequences of the USSR and Stalin. But there was little published information available in my youth. As an undergraduate student in university, I recall the scholarly debates of the late 1970s and early 1980s, when different accounts were debated, usually framed by the general context of the Cold War.

Then I read Robert Conquest's *The Harvest of Sorrow* in 1986. It brought clarity to me, even though the book was not without its critics. The Holodomor was a deliberate famine inflicted for ethnic and political reasons. In the immediate aftermath of the collectivization of agriculture, and as a way to undermine Ukrainian opposition to Soviet power, Stalin weaponized food. The state policy to confiscate grain, while simultaneously prohibiting relief measures from abroad and exporting grain to finance industrialization, led to the death of more than four million Ukrainians. The Museum's documentary tells the story of the Holodomor, and also contrasts the work of two different journalists, Gareth Jones and Walter Duranty.

Jones was a young Welsh journalist who had previously been a secretary to British Prime Minister David Lloyd George, then turned to investigating world politics. After writing accounts of Hitler's rise to power in Germany, Jones turned to Russia, where he had travelled two years earlier. His work on Russia drew from first-hand experience, as he witnessed widespread famine in Ukraine during his trek along the railway outside Kharkiv. His

newspaper articles in March 1933 made a direct link between the famine and Soviet policy.

Jones was heavily criticized by other prominent correspondents for his articles. Walter Duranty, the Pulitzer Prize winning journalist from *The New York Times*, claimed that while food shortages were evident, there was no famine in the land. By denying the accuracy of Jones' coverage, Duranty and other established journalists not only protected the image of the Soviet Union but tarnished Jones' reputation. Jones was banned from returning to the Soviet Union and ended up travelling to China to cover the Japanese occupation of Manchuria. He was kidnapped by bandits and murdered in 1935, around the same time as his 30th birthday. The courage he summoned to investigate and communicate atrocities stands in stark opposition to the work of Duranty, who treated fiction as fact and helped propagate denial of genocide. The Museum's documentary film raises legitimate questions about the role of the media during mass atrocities, noting its power to both reveal and to conceal – a reality that continues today.

▼ The Breaking the Silence digital study table.
▶ Visitors can watch survivor's and witnesses' first-hand accounts.

Public remembering is critical to cultivating awareness of crimes against humanity. This is why we must share what we learn, openly discuss the consequences of such atrocities and, like Wegner and Jones, seek to create greater public awareness. Compared to the courage of Wegner, Jones, Bishop von Galen, Lemkin and others, it seems a small thing to remember, share, and speak out. Yet out of such efforts we can better understand the dangerous paths to gross violations of human rights, honour the victims, and draw lessons that can inform our actions today.

Remembering is a verb that requires action. By pausing to remember, and by gathering together to remember, we help transform atrocities from different times and places into a living part of our collective memory – here and now. We remind everyone that there is a great cost to all of us when memory is lost, and that the tragedy of loss is multiplied by forgetting. In this regard, our collective memory is a fundamental part of the great partnership we have with our ancestors and with the generations yet to come. And this opportunity to remember together is how we keep that partnership alive.

Moving past the theatre, we enter the Breaking the Silence gallery with its large, digital study table and survivor testimony carrels. Here, we can explore many stories

about genocide and mass atrocity. In the touchscreen table, these stories are displayed as points on a world map. Each story is told through a common framework: its historical context; the violation of rights; the denial or minimization that inevitably accompanied each aftermath; and finally the efforts of survivors, witnesses and their advocates to break silence and shed light on what happened. The study table includes images and documents that reveal the common patterns of atrocity and the courage of witnesses and survivors in sharing their experiences.

The study table provides unique opportunities for teachers and students to explore such topics as the transatlantic slave trade, different genocides, the partition of India, the Red Terror in China, Cambodia or Ethiopia, Afghanistan under the Taliban, human rights violations in North Korea, and other human rights atrocities. In the carrels beside the table, we find dozens of video clips of first-hand accounts by survivors, witnesses and activists associated with each atrocity. It is clear that our work is not done: public awareness needs to be nourished and, despite the repetition

of the phrase "never again," there are many stories that could be added to this gallery.

Circling back around a display wall, we enter a gallery called Turning Points for Humanity. The devastation and atrocities of the Second World War fed a powerful conviction for affirmative assertions and support for human rights. In this gallery, a focus is placed on the efforts of many people, including Canadian John Peters Humphrey, to create a Universal Declaration of Human Rights. The first line of its preamble is aspirational: "Recognition of the inherent dignity and of the equal and inalienable rights of all members of the human family is the foundation of freedom, justice and peace in the world." And the first line of Article 1 is the same line we saw earlier in our Museum visit: "All human beings are born free and equal in dignity and rights."

◀ The Turning Points for Humanity gallery.
▼ The Human Rights Revolution case features the Universal Declaration of Human Rights and the four fundamental freedoms.

Along the wall where artifacts and text explain the Universal Declaration and subsequent international legal conventions, there are four digital "books", each about two metres high. Across from the wall, you will find short films related to the rights articulated in these international declarations. The films are activated using gesture-based technology. When we stand in a small pool of light and point at the screen, a video narrator appears to offer an introduction. We point again to choose a film to watch, based on stories gathered from around the world of people taking action for positive change. The themes of the films include freedom of religion, women's rights, children's rights, the rights of persons with disabilities, freedom from racial discrimination, the rights of Indigenous Peoples, gender and sexual diversity rights, and freedom from human trafficking.

On the other side of these books, we find images of the honorary Canadian citizens. The Canadian government had recognized six different individuals with this privilege, including Raoul Wallenberg, Nelson Mandela, the Dalai Lama, the Aga Khan, Malala Yousafzai and Aung San Suu Kyi.

The digital books in *Turning Points for Humanity* explore community-based struggles and how individuals are turning their human rights hopes into realities.

In light of the controversy surrounding the plight of the Rohingya in Myanmar – which was declared a genocide by the United Nations and the Government of Canada in 2018 – we made changes to this exhibit. Suu Kyi had failed to condemn attacks against the Rohingya carried out by Myanmar's military. In the fall of 2017, the Canadian Museum for Human Rights began inviting visitors to engage in dialogue about her role. This dialogue led the Museum to later dim the light that illuminated her portrait in this gallery and remove a second image that had been included in the human rights timeline in the Museum's introductory gallery, What are Human Rights? In October 2018, Suu Kyi's honorary Canadian citizenship was revoked following unanimous votes in the House of Commons and the Senate. Such developments remind us that the stories we tell are often unfinished, and current events continue to add new chapters to our content.

Actions Count

Walking out of the Turning Points gallery, we pass by a set of glass elevators and into a gallery called Actions Count, which has a special focus on youth. It explores how people can take action for human rights at school and in their communities. We play an interactive table game, navigated by using the shadow of our hand: It's Your Choice allows players to select actions like attending rallies, volunteering with a local charity, or speaking up about matters of concern as ways to support human rights. The intent of the game is to underscore how human rights are all around us every day and that small actions can add up to meaningful change.

◀ A student plays It's Your Choice in the Actions Count gallery.
▲ Travis Price, founder of Pink Shirt Day, visits the gallery.

On the walls and in the digital insight stations are stories
that highlight the role of youths and everyday Canadians.
One of the inspiring stories is about two teenagers from
Nova Scotia, Travis Price and David Shepherd. In 2007,
they heard classmates making fun of a student for wearing
a pink shirt to school. Price and Shepherd decided to
purchase pink shirts and distribute them to everyone at
the school in support of the student. This action stopped
the bullying and launched Pink Shirt Day, an annual
national event that encourages people to take action against
bullying. As Price noted, people can "just get to a point
where they say enough is enough" and through these small,
yet deliberate actions, they can make a difference.

In the Actions Count gallery, we also find information
about the Georgetown Boys. In the 1920s, compassionate
Canadians raised money and lobbied the government to
ease restrictive immigration legislation and then admit and
support the refugees, providing a new start for orphans of
the Armenian genocide. This historic aid project marked

the first time that Canada accepted refugees based on humanitarian values. The effort was known as Canada's Noble Experiment. More than 100 Armenian boys learned to farm in Georgetown, Ontario and became known by the name of the community in which they lived. About 40 Armenian girls and women were also accepted, becoming domestic workers. Not all the refugees received equal care and opportunity. Yet the account is an example of Canadians acting to promote the rights of others. Despite the efforts of Canadian authorities to anglicize their surnames and encourage cultural assimilation, these young Armenians remained devoted to preserving their heritage. The Georgetown Boys had their own Armenian teacher and produced their own magazine, call *Ararat Monthly*. Many of them settled permanently in Canada and later expressed great gratitude and fond memories of their experience, and were active in subsequent humanitarian and charitable efforts for other immigrants.

Rights Today

We now follow the alabaster ramps to the fifth-floor gallery, called Rights Today. Here we find a variety of exhibits and presentations that focus on how we are influenced by – and how we can respond to – human rights struggles and successes in the contemporary world. A small theatre shows three short films about media literacy, news coverage and advertising. On another wall, a large map of the world is projected, displaying data and information that inform our understanding of the shifting state of human rights around the world. In the centre of the room, we examine an exhibit that features a selection of everyday objects in an array suspended from the ceiling. Mobile phones, bottles of water, and other objects spark conversations about advances and setbacks in human rights. They remind us to think about the potential human rights implications of the consumer choices we make.

A mobile device, for example, allows us to communicate with each other around the world. We can quickly disseminate messages that inspire action for human rights and overcome barriers to freedom of expression. An example is the way that social media inspired a pro-democracy uprising in the Middle East during the Arab Spring of 2011. At the same time, we need to be aware that some components used in the manufacture of mobile phones are mined using child labour in Africa.

Stepping away from the array, we come to a tapestry of global human rights defenders – people from around the world who are engaged in defending human rights. In front of the tapestry, we explore digital touchscreens with multimedia presentations (video, sound, images, text and documents) that profile twelve individuals who have devoted their lives to promoting human rights.

Everyday Objects installation in the Rights Today gallery.

One example is Marina Nemat, an Iranian-Canadian who was arrested as a 16 year old in Tehran in 1982 for her opposition to the oppressive policies of the revolutionary government of Iran under Ayatollah Khomeini. She was tortured and raped in the notorious Evin prison and sentenced to death. Her survival was the consequence of a prison guard's attraction towards her: Nemat's sentence was reduced to life in prison but required her to marry this prison guard who had been one of her torturers. She was also forced to convert to Islam. After her husband was killed for political reasons, his parents bought her release from prison. Nemat then escaped from Iran and eventually made her way to Canada, where she wrote a best-selling account of her experience, called *Prisoner of Tehran*. Now living in Toronto, she has become a prominent human rights advocate. Nemat has noted that those who remain silent about injustice become its accomplices. "There are a lot of bad things happing in in the world that could be prevented and there is something I can do by speaking out," she explains: "It is the bystander that allows atrocities to happen, and I just don't want to be a bystander."

We continue walking along the west side of the gallery, which opens onto a terrace overlooking the Stuart Clark Garden of Contemplation. In front of us we see a door to the Carte International Reference Centre, which is open to the public during select hours or by appointment. It provides a space for study and learning, reference and information literacy services, and access to the Museum's collections.

In addition to supporting the educational, research and information needs of Museum staff, the centre serves the general public, school groups, visiting scholars and academics, and the global human rights community.

Expressions

Ascending further to the sixth floor, we find Expressions, a gallery space for temporary exhibitions. The Museum also houses temporary and travelling exhibitions in a much larger exhibition space on the first floor. During its first four years, the Canadian Museum for Human Rights was pleased to present a variety of exhibitions developed by our own staff and by other institutions and artists. In all cases, the choice and development of these exhibitions was designed to support the Museum's commitment to inclusive design, accessibility and visitor engagement.

In 2015, we welcomed the Magna Carta as the centrepiece for the first exhibition to run in the Museum's new Level 1 Gallery. *Magna Carta – Law, Liberty and Legacy* was a national travelling exhibition celebrating the 800th

The Magna Carta experience continues in the Museum's online quiz game, which tests players on their knowledge about the meaning behind images related to Canada's democratic history.

anniversary of the great charter that laid the foundation for basic principles of democracy and human rights. On loan from Durham Cathedral in the United Kingdom, the historic document was exhibited in a setting that recreated King John's tent at Runnymede (the field in England where Magna Carta was sealed). One of the world's most famous historic charters, the Magna Carta was showcased alongside some of Canada's most important foundational documents.

In 2018, the Museum was proud to open an exhibition for the 100th anniversary of Nelson Mandela's birth, created in partnership with the Apartheid Museum in South Africa. Mandela's unbreakable will inspired people around the globe to mobilize for human rights. The exhibition *Mandela: Struggle for Freedom* was a rich sensory experience of imagery, soundscape, digital media and objects that explored the earthshaking fight for justice and human dignity in South Africa – and its relevance to issues of today. Among its many dramatic visual features and original artifacts, the exhibition replicates Mandela's eight-foot by seven-foot prison cell. Mandela is one of only six people to be made honorary Canadian citizens. He travelled to Canada a few months after his historic 1990 release from prison to thank its leaders and citizens for their support. The exhibition includes a message he wrote at that time in the Senate's Golden Book.

Another powerful exhibition was *Sight Unseen: International Photography by Blind Artists*, which explored how the blind can often see in ways that the sighted cannot. The show, which ran in the Level 1 Gallery in 2016 was presented to mark the 10th anniversary of the United Nations Convention on the Rights of Persons with Disabilities. It is also the first museum exhibition in the world to showcase three-dimensional, tactile imaging technology developed by 3DPhotoWorks in New York as a breakthrough for people with vision loss – allowing them

▲ This replication of Mandela's prison cell plays five short film projections on the cell walls.
◀ Share the message of freedom on social media by creating an anti-apartheid poster in-gallery or online.

Loi d'habitation séparée. Loi n° 41 de 1949

Paragraphe 5(1) Les personnes noires peuvent
...

Paragraphe 5(2) Les personnes d'un ...
n'importe d'un autre ...
elle travaillent pour une année ...

TAXI RANK

FOR WHITES

PRETORIA

VOORSTEDELKE
SUBURBAN ST

NON-WHI

Loi d'immoralité, loi n° 23 de 1957

Article 16 Il est illégal pour une personne blanche d'avoir des
relations sexuelles avec une personne non blanche du sexe opposé.

Immorality Act. Act No. 23 of 1957

Section 16 It is illegal for white and non-white people of the opposite
sex to have sex with each other.

FOR USE BY

VIR GEBRUIK

Reservation of Separate Amenities Act. Act No. 49 of 1953

Section 2(1) Public places can have separate counters, benches, seats and other
amenities for black, coloured, Indian and white people.

Section 2(2) It is illegal to use a separate counter, bench, seat or other amenity
one is not part of the group allowed there.

Loi sur les commodités publiques, loi n° 49 de 1953

Paragraphe 2(1) Les lieux publics peuvent être munis de comptoirs, bancs, sièges et
autres commodités distincts pour les personnes noires, métisses, indiennes et blanches.

Paragraphe 2(2) Il est illégal d'utiliser un comptoir, un banc, un siège ou une commodité
qui n'est pas réservé au groupe auquel on appartient.

BLACKS, COLOUREDS
& ASIANS

BANTSUNDU, KLEURLINGE
EN ASIERS

Bantu Education Act

Section 2(1)(a) The state has...
Black and white education sy...
only minimal education...

EUROP

BL

Loi d'éducation bantoue, loi n° 47 de 1953

Alinéa 2(1)(a) L'État a les pleins pouvoirs sur l'éducation des personnes noires.
Le système d'éducation noir et le système d'éducation blanc sont séparés,
et les personnes noires ne doivent recevoir qu'un minimum d'éducation.

to "see" photographs and fine art with their fingertips. The main exhibition featured photographs by artists from around the world with varying degrees of vision loss, who use different technologies and creative methods to express what they see.

For the 150th anniversary of Canadian Confederation in 2017, the Museum created three original temporary and travelling exhibitions, and partnered on a fourth.

The first, which opened in the Level 1 gallery at the end of 2016, was called *1867: Rebellion & Confederation*, developed by the Canadian Museum of History in Gatineau, Quebec, and adapted by the Canadian Museum for Human Rights. This exhibition explored the stormy birth of Canada – three decades of armed revolt, brutal repression, negotiation and compromise between 1837 and 1867. More than 100 artifacts on display included weapons, period furniture and clothing, and famous original documents such as the Durham Report of 1839 and pages of the draft British North America Act. The Manitoba Museum contributed a 170-year-old Métis

saddle with quill and beadwork, and a sword given in 1839 to Métis leader Cuthbert Grant (the namesake of Winnipeg's Grant Avenue).

In early 2017, the Museum then opened *Our Canada, My Story*, an exhibition in the Level 6 Expressions gallery. Seven Canadians shared their uplifting, contemporary stories about human rights challenges in Canada. They included a Halifax man who arrived as a refugee from Somalia and became a Halifax firefighter and basketball coach; a Calgary dancer with cerebral palsy who had a leading role in a theatrical performance company; and a woman in Montréal who, with her same-sex partner, won the legal right to be equally recognized as the parents of their children. Visitors were invited to make a connection that challenged perceptions and celebrated diversity – sparking reflection about how we are different, how we are the same, and what links us all as Canadians.

◀◀ This 16-foot-tall wall in the *Mandela: Struggle for Freedom* exhibition shows the oppressive laws under apartheid rule.
◀ *Our Canada, My Story* exhibition.
▼ *Points of View* exhibition.

Next came *Points of View*, a crowd-sourced national photography exhibition that opened in the Level 1 gallery in the middle of 2017. The Museum had invited people across Canada to submit photos under four different human rights themes: Reconciliation; Inclusion and Diversity; Freedom of Expression; Human Rights and the Environment. Almost 1,000 submissions were received, from which 70 were chosen for the exhibitions and five received awards. The award-winning photographs were also replicated in three-dimensional tactile versions, enabling blind visitors to "see" the art through their fingertips.

The final exhibition for Canada 150 was called *Rights of Passage* and opened on December 10, 2017: International Human Rights Day. It invited visitors to peer through the lens of four different eras in Canadian history since 1867 to learn how people were thinking about human rights at the time. Projected wampum beads danced to the sound of voices, shifting into designs created by art students at Winnipeg's Children of the Earth High School. A dress made from wearable technology (fibre optic fabric, laser

The *Empowering Women: Artisan Cooperatives that Transform Communities* exhibition.

wire and LED lights) changed colours when visitors stepped on a hashtag. A Victorian-era "magic lantern" projected images of early human rights struggles. Visitors could also tune in to war-time broadcasts on a period radio set, switch channels on 1970s vintage TV screens, or watch Instagram posts appear above shifting holograms. Indigenous oral traditions were also showcased as an enduring source of knowledge. The exhibition includes personal accounts of Indigenous Peoples' efforts to resist assimilation, preserve a unique history and alter the path of the future.

Two other exhibitions that have been presented in the Level 6 Expressions gallery have also left a lasting impression with me.

Empowering Women: Artisan Cooperatives that Transform Communities came to us in 2016 from the Museum of International Folk Art in Santa Fe, New Mexico. It used colourful folk art objects, images and video to bring stories from 11 countries to life. It also told powerful stories – of a Moroccan artist who taught a village of women to read and to lead; about an embroiderer in India who took out

her first business loan; or Rwandan sisters who began a weaving collective that expanded to include 4,000 women, both Tutsi and Hutu.

But the part I liked best was created by staff from the Museum, who travelled to Guatemala to meet the women of an Indigenous Mayan weaving cooperative. A virtual reality experience called "Weaving a Better Future" was produced and can still be downloaded online. These 360-degree videos show the women working and living in their homes and marketplaces. Two of the Indigenous women featured in the video came to Winnipeg from Guatemala to participate in the exhibition opening and demonstrated their weaving for visitors. We still carry their textiles and woven products in our Boutique.

The last exhibition I'd like to highlight is part of our ongoing efforts to play a role in the important process of reconciliation between Indigenous and non-Indigenous people in Canada. *The Witness Blanket* is an artistic installation that we exhibited on Level 6 starting in December 2015 – the day before the Truth and Reconciliation Commission (TRC) submitted its final report to the Government of Canada. Created by

West Coast Salish artist Carey Newman, *The Witness Blanket* was created from 800 pieces of residential school history. A battered shoe. Braids of hair. A hockey trophy. A wooden door. A black-and-white photograph. A piece of stained glass. They were all silent witnesses to the Indian residential schools era that lasted from the late

▲ Virtual reality app Weaving a Better Future allows users to experience a Guatemalan weaving cooperative.
▼ *The Witness Blanket.*

The items were donated by residential school survivors and their families, or collected from band offices, friendship centres, churches and the sites of former residential schools.

1800s until 1996. Collected from 77 sites of former residential schools these objects were given a voice in a 12-metre-long artwork created as a national monument to the children.

This powerful piece – set in a large cedar frame that resembles a quilted blanket – is an example of several exhibits and programs in the Museum that educate visitors about the legacy of residential schools in order to facilitate empathy, encourage mutual respect, and foster a desire for reconciliation. In its summary report, the TRC made specific reference to the Canadian Museum for Human Rights and other national museums as places to promote reconciliation through education. Newman, whose father is a residential school survivor, said he made *The Witness Blanket* for people who want to learn and are ready to work towards a better future together. He and his team spent over a year travelling 200,000 kilometres around the country to gather objects and stories. A documentary film about the project was screened in late 2018 at the Vancouver Film Festival and was nominated for Canadian documentary of the year.

Inspiring Change

We now reach the highest gallery in the Canadian Museum for Human Rights, which is on Level 7, called Inspiring Change. We are immediately drawn to a bright red, sequined prom dress standing in a glass case. This artifact is used to relay the contemporary story of Maréshia Rucker of Wilcox County, Georgia who with her friends organized her school's first racially integrated prom – in 2013. This exhibit surprises most visitors because of how recently it occurred. This normally leads to a discussion about the persistence of the practice of racial segregation, despite decades-old laws against it. Other stories, of the Raging Grannies of Victoria who use humour to draw attention to human rights issues, or Egyptian graffiti art used as a form of resistance, draw additional attention to many ways that change can be inspired. Change might look like a prom dress, a piece of graffiti or a yarn-covered tree (like those created by grandmothers of AIDS orphans in South Africa).

Visitors can fill out cards in the Inspiring Change gallery with their ideas and hopes for a world that promotes human rights for everyone.

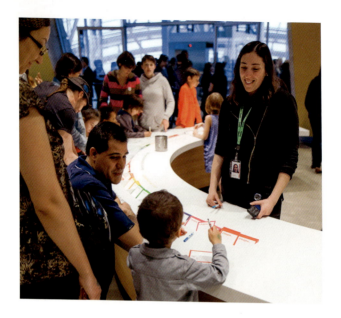

At this point in the tour, I would now ask you to join the conversation by leaving a message for others that shares your own vision for human rights. In the middle of this gallery are two large, curved counters where we find cards and markers. At the top of each card, there is a message – such as "I imagine" or "Reconciliation is…" – designed to prompt your thoughts and ideas. When you are finished your message, you place it in the racks that line two of the gallery walls, where dozens of other cards have been completed by visitors from across Canada and around the world. Reading their heartfelt messages can be an emotional experience.

Around the corner, we stop by the listening stations, slipping on a set of headphones to hear music inspired by human rights themes. Music has always been an important part of human rights movements – creating awareness of violations, appealing for peace and hope or mobilizing people to action.

The Israel Asper Tower of Hope

From Level 7, we can continue upwards by climbing a spiral staircase or boarding the glass elevator to the Israel Asper Tower of Hope. The tower is a physical manifestation of the elevated perspective that a journey through the Museum offers. We started in the dim, subterranean environment of Bonnie & John Buhler Hall. We end in the clouds, with the light so bright that you may need your sunglasses. On a clear day, the light and the view from the tower convey to visitors that the climb has its rewards, a fitting conclusion to the tour of the galleries.

There is much more going on in the Canadian Museum for Human Rights than a physical visit can reveal. The visitor experience in our galleries is only one way the Museum pursues its mandate to cultivate dialogue and reflection on human rights themes. Some of the human rights stories featured within these walls can also be found on our website, designed to seek engagement with virtual visitors. Social media is another important tool that we use

every day to engage people in thought and conversation about human rights. This online engagement fits very well with the Museum's focus on building a collection of human rights stories and dialogue, and on expanding our collective, public memory to include perspectives and experiences that are not well known or understood.

Educational and public programs are also central to our work. The Museum takes its educational role very seriously. We have developed a dozen different programs for school groups and worked with education departments and ministries from all 13 provinces and territories to ensure our educational programs are coordinated with their learning outcomes objectives. We welcome groups of all ages from across the country and around the world. While we are thrilled to accommodate groups that travel from afar, we are also devoted to connecting students to the Museum through virtual tours. Students are able to engage in online, interactive exploration of the Museum galleries and conversation from their classrooms wherever they are located.

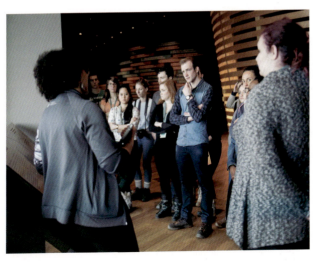

École des droits is a week-long intensive program at the Museum for Francophone students from Canada and France, focussing on themes of diversity and inclusion.

In addition, public programs and events at the Museum are both frequent and diverse. Public forums on contemporary topics, book launches, guest speakers, film screenings and special events, workshops, family activities, musical and artistic performances all engage visitors in inspirational ways to inform and expand our understanding of our rights and responsibilities to promote the dignity and respect of all people.

Visitors might also be interested in guided tours that focus on specific themes found in the Museum. These tours can highlight specific exhibitions, the architecture or focus on stories. One example is the Mikinak-Keya Spirit Tour, inspired by ceremony and living oral traditions and developed with Indigenous Elders. It explores the powerful connections between First Nations' sacred knowledge and worldviews and the Museum's human rights journey as expressed through its architecture. Participants gain unique insight into the seven sacred teachings that encourage responsibility for treating all living things with respect.

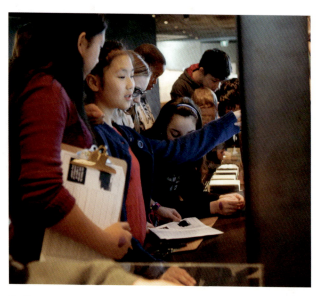

The Museum welcomes more than 25,000 students annually, from kindergarten to grade 12, offering curriculum-connected programs and tours about human rights.

A further expression of the Museum's mandate to cultivate reflection on human rights themes is the Boutique. Here, visitors can shop with confidence, browsing among a wide array of socially conscious and fair-trade items. Many of the Boutique's products are connected to content found in the galleries, a good way for visitors to share human rights stories with others.

The Mikinak-Keya Spirit Tour.

I'll now leave you back on the ground floor with a few parting thoughts. Thank you for this opportunity to share the Canadian Museum for Human Rights with you. I trust that you will want to visit again and share with others your own thoughts and impressions.

The Museum began as an audacious idea. That audacity continues to shape all that we do. Israel Asper thought big – he reached for the stars and encouraged others to do so as well. And in that reach, Izzy sought the magic to stir the souls of all those who would visit the Museum. He thought first and foremost about the children and grandchildren to come, about how to inform and encourage them to stand for their rights and the rights of all.

Courage can be found at the heart of the most meaningful stories we tell. It is the courage to take a stand for dignity and respect, for oneself and for others. Our stories of courage and conviction provide abundant examples of the active ingredients necessary for human rights to flourish. They also highlight that, despite the tragedies and atrocities of the past, present, and future, we are blessed with the understanding and capacity to address the challenges that confront us. This is the gift that Israel Asper desired to leave Canada and the World. And this is why the work of the Canadian Museum for Human Rights is so valuable for all.

This edition © Scala Arts &
Heritage Publishers Ltd, 2019
Text and photography © Canadian
Museum for Human Rights, 2019

First published in 2019 by
Scala Arts & Heritage
Publishers Ltd
10 Lion Yard
Tremadoc Road
London SW4 7NQ, UK
www.scalapublishers.com

In association with
Canadian Museum for
Human Rights
85 Israel Asper Way
Winnipeg
Manitoba R3C 0L5
Canada
www.humanrights.ca

ISBN 978-1-78551-211-7

Edited by Robert Ferguson
Designed by Jade Design
Printed in China

10 9 8 7 6 5 4 3 2 1

Chronic Creative: 52, 66, 69
Aaron Cohen: Front cover, 2-3, 10,
11, 15, 23, 32, 37, 57, 62, 64, 65,
68, 73, 76 (bottom), 78-79, 80, 81,
88, 89, 90, 92
Thomas Fricke: 5, 6, 16-17, 18, 36,
91, 93 (both), 94
Dan Harper: 8-9, 26-27
Gideon Lewis: 8
Douglas Little: Back cover, 28-29,
31, 46
Ian McCausland: 7, 20-21, 25, 27,
34-35, 34, 35, 38-39, 39, 40, 42,
44-45, 48-49, 50, 51, 54-55, 59,
67, 71, 87,
Jessica Sigurdson: 63, 75, 82-83,
84-85, 85, 86, 90
Lindsay Winter: 12-13
John Woods: 30, 76 (top)